A MANUAL OF
CLAY-MODELLING

A MANUAL OF
CLAY-MODELLING

by

Mary Louisa Hermione Unwin

YESTERDAY'S CLASSICS

ITHACA, NEW YORK

This edition, first published in 2018 by Yesterday's Classics, an imprint of Yesterday's Classics, LLC, is an unabridged republication of the text originally published by Longmans, Green, and Co. in 1912. For the complete listing of the books that are published by Yesterday's Classics, please visit www.yesterdaysclassics.com. Yesterday's Classics is the publishing arm of the Baldwin Online Children's Literature Project which presents the complete text of hundreds of classic books for children at www.mainlesson.com.

ISBN: 978-1-63334-103-6

Yesterday's Classics, LLC
PO Box 339
Ithaca, NY 14851

PREFACE

Die Kunst, O Mensch, hast du allein

THERE are many signs that Art is to be made in future a part of general education; and, as is often the case with a movement which is widespread, the root of it is not simple, but divided into several ramifications. Many educational principles which are accepted independently of each other in the first instance, when carried out in practice are found to lead to the introduction of artistic training in ordinary school-work.

Of primary importance is Froebel's principle, that the constructive power of children, which was long trained only by chance, must in future be systematically attended to, so that they may be accustomed not only to hear and receive information, but in some definite way to exercise their faculties for shaping and making. In other words, the child must learn to express himself with his hands by making objects out of varied material.

Then, again, as a basis for Technical Education, the importance of using and improving the sense of touch, and the kindred sense of sight, is daily more and more insisted upon by those who have to deal with the rudiments of this kind of instruction.

No one can study the principles of the right bringing-up of children without becoming aware of the necessity for Manual Training on moral and hygienic grounds. It is important, however, to remember that educational Handwork is not a mere question of muscular development. The aim of all work at school should be moral and intellectual improvement, and Handwork should form no exception to this rule. In this kind of instruction, if it is appropriate to child-life, and not a premature industrial training, the brain is reached through the muscle, and muscular activity is employed to expand the intellect.

No sooner are we led on varied grounds to see the need of teaching children to use their hands in construction, than we feel the advantage of teaching them to make things as beautiful as possible; and as soon as the desire to make passes into the desire to make beautifully, we pass from mere industry to at least a rudimentary love of Art. That 'industry without Art is brutality,' is a fact which has never been better illustrated than by Lord Beaconsfield in his description of the Black-country locksmith, whose workshop, with its apprentices, is powerfully depicted in 'Sybil.'

The truth is that to-day statesmen, poets, preachers, philosophers, economists, and friends of education, are all at one in emphasising the need of a widespread training in Art.

If, then, Art is to be taught in elementary schools, what form of it is most suitable for the purpose? I believe none is of more universal application or more

fundamental than Clay-Modelling. As a foundation for artistic training, Modelling is superior to Drawing; for objects which are drawn must be represented as they appear, whereas objects that are modelled must be treated as a whole, just as they are in Nature. The expression of an Object with pencil or brush is a reduction of what is handled in space of three dimensions to the picture-plane, which is space of two dimensions. In Modelling, the student deals with the round, with mass, and with bodies as they are fully known to us. Modelling is an older art than Painting, and the best authorities insist upon it that the studio of the sculptor is the best preparation for the painter and the draughtsman.

The first rudiments of the Artist's skill are Perception and Manual Dexterity. These can be divided in thought, but not in practice. In trying to express what we see we learn to perceive more accurately.

The child-artist in his first school must learn to produce in clay the perceptions which he has acquired of natural objects. There is a true analogy between language regarded as the raw material of orators, poets and writers, and clay, which is the raw material of the artist. As artists in words must acquire command over language, so the modeller must learn to express in clay the ideas which he has derived from an accurate study of some natural object. He must learn, if I may venture on the phrase, 'to talk in clay.' This he can only do when his power of perception of natural objects is equalled by his manual dexterity. He must, in addition, learn the rules of his art, which have been evolved in the course of many generations, without appearing to be

fettered and trammelled by their limitations. For school purposes, Modelling has the advantage over Carving. The plastic clay offers but little resistance to the hand of the modeller, and readily takes any form which it may be his will to produce. Wood and stone offer a stubborn resistance to the expression of the mental conception in these materials.

The sculptor has to accomplish the presentation of his ideal by hewing away that part of the material which surrounds his design while yet in the solid block. The modeller can build up his conception by a process of addition, and he can improve his mental conception as he works on the clay. It is easier for the modeller to correct his mental image, when the model of it is seen to be false, than for the carver, whose mistake remains unalterable.

The first training of the young artist is perception of Nature. In imitating an object he learns its nature. By words his teacher will explain to him the structure of the object and the meaning of characteristic points in it. By words the teacher may explain to him the beauty of form which may be observed in the natural object. By words, also, the child may be helped to see this beauty. For the perception of beauty in an object is an act of reason, in so far as it involves perception of unity in diversity, and tracing continuity where it is not apparent to a mere animal gaze. The child, however, can only really seize and fully apprehend the form and beauty of the object by an effort of thought and constructive imagination, such as is needed to make a model.

The commencement of the study of an object must needs be a process of analysis and dissection. How can unity be better restored to the fragments thus produced than by modelling the object as a whole?

Language, it has been well said, is a liberation of the understanding; and so, also, the modelling of a beautiful form is a liberation, or setting free, of the imagination.

It is of great consequence that the teacher should resort in the beginning to Nature itself, and not set the young child to copy beautiful forms which have been abstracted by artists from natural objects in past time. It is not ready-made Art which the child needs, but Art in the making. The child must learn to see with his own eyes at once the riches and the simplicity of Nature. He must perceive the beauty of an object, and in modelling it build up the beauty which he has comprehended.

Of course I am not advocating a crude naturalism. A work of Art is the work of a true artist, so far as it presents Nature; but yet the spectator must always be conscious that it is a work of art, and not Nature. An attempt to present an object by mere accumulation of details, slavishly imitated, and added together piecemeal, does not produce a work of art, even in a rudimentary way. Although the details must be exactly studied, and the meaning of each understood separately, the object must be rendered as a whole, and some details must be merged in the general mass for the sake of due effect in light and shade.

It will be the teachers' pleasure to show their pupils

how beauty in natural objects is, so to say, scattered throughout them, and that it is the eye of the artist which condenses or concentrates it, and his hand which presents the beauty of Nature in a readily visible form.

All the magic of beauty which may bewitch the mind of man, and raise it far above the monotonous round of life's daily drudgery, may be drawn out of a few objects such as have been selected by the author of this little book.

I have observed that children take the greatest interest in the occupation, both while modelling these objects, and afterwards, when the models are completed.

It is fortunate for human progress that much that is most beautiful is most common and most cheap, demanding for its appropriation only some effort of attention and will. In Art, at any rate, there needs no costly apparatus to elevate the mind. Although few can become artists, all can become lovers of art, and learn to look on the artist's productions with sympathetic acknowledgment of his power. Many must apply themselves to art before one man of real genius can arise to adorn it. Apart, however, from all high success, the mere conscientious pursuit of an art enables the student to appreciate, as he could not otherwise do, the highest kind of work in the art which he studies, and—what is of great consequence—to know good work from bad. 'In the temple of Art, many who can never stand on the pinnacle may find a safe corner near

the ground,' and education of which art forms a part will make the lives of all better and happier; for through a right study of Art the child may find a new joy in his home and usual surroundings. After a very little study of Art, things which seemed common and uninteresting become invested with rare charms and delights, which transcend all previous knowledge and belief, and raise the student to a new and purer atmosphere of life and thought.

While dwelling on the formative value of Clay-Modelling in education, I must not omit briefly to call attention to its utilitarian advantages. Clay-Modelling may be employed to illustrate and support many branches of study. It may help to make more intelligible a geographical knowledge of the surface of the earth, and render many events in history, such as battle-fields and sieges, more interesting to the children. In Science and Natural History its applications are endless; as an example, I would mention the modelling of a bean during germination at short, successive intervals, with the object of impressing on the mind the process of development. In the study of Horticulture, a series of models of a particular variety of the carrot or potato, when the plant has been subjected to varying treatment, would be of considerable practical value. Numerous instances will occur to every teacher, and therefore it is unnecessary to dwell at greater length on the utility of Clay-Modelling.

T. G. ROOPER.

CONTENTS

INTRODUCTION

§1. Aim of Manual

THIS Manual of Clay-Modelling and the Course of Lessons which it sets forth are intended to serve both for Classes of Teachers and of Scholars, and, excepting where the contrary is specified (as in *§10*, *§12*, and *§17*), the directions may be followed as they stand in either Class. The principles of the method of working are, of course, the same in both cases, but older pupils will make more rapid progress, and go through the whole Course in less than half the time required by a Class of Children.

§2. Artistic Value of Clay-Modelling

The practice of Clay-Modelling, when it is taught in the right way, develops the artistic powers more than any other form of Educational Handwork. Hitherto the artistic side of a child's nature has been much neglected in the ordinary school curriculum, and what art teaching has been given has been of a kind

1

likely to crush rather than develop all artistic instinct, unless a child has been endowed with much more than the usual amount. In the Modelling-lesson there should be as little of the routine of ordinary lessons as is possible, so that it may be regarded as a recreation and a pleasure, and that each child may be free to do the work by the method he likes best, and to realise the delight of exercising his creative power—a feeling which is strong in all children. The better he succeeds, the further will his imagination be stimulated. A child is always ready to receive new impressions, and often sees things with a clearer eye than his elders, not having already made up his mind how he thinks they ought to appear. Thus there is sometimes a freshness about his work which is wanting in that of older people. He will often perceive and seize the essential characteristics of an object, probably without realising how he does so; and it should be our aim to develop and strengthen this power before it becomes dulled, that it may not be an accident that the model of the leaf looks leaf-like, or the model of the shell, shell-like. The earlier, therefore, that we begin, the better, and the more hope will there be of achieving good results.

§3. Teaching of Clay-Modelling should Precede that of Drawing

The teaching of Clay-Modelling should precede, not follow, that of Drawing, but if they are studied together by the same methods they will mutually aid each other. The same principles apply to both arts, but

Drawing is a more abstract art than Clay-Modelling. In Drawing there are only two dimensions—length and breadth—to work with, instead of three, and therefore in Drawing the laws of foreshortening and perspective have to be understood, which at the outset present great difficulties to a child. But in Clay-Modelling the object is copied exactly as it is, in three dimensions—length, breadth, and height—and has to be considered from all sides; so that in modelling an object more is learnt than in simply drawing it, when only one point of view is studied.

In order that the two arts may help each other, the objects which a child has already modelled may be given as the first exercises in Drawing, and he should be taught to shade them in a simple way.

§4. *Reasons for its Introduction into Schools*

But it is not only for the end itself, but for the means by which this end is attained, that Clay-Modelling is specially valuable as a method of mental and manual training. It is a subject which appeals strongly to children of all ages, and it may be begun in the lowest classes, and carried on right through the school without a break, the work being continuous throughout. Many good habits of mind which may be more easily developed while a child is young are induced by its practice.

§5. Powers Developed by Clay-Modelling

The principal powers which the practice of Clay-Modelling develops are:—

(1) Observation.

(2) Accuracy, especially in the perception of form.

(3) Dexterity of hand.

(4) Sense of form and proportion.

(5) Greater power in drawing.

(6) Love and appreciation of the beautiful in form.

(7) Enjoyment of the creative power in oneself.

(8) Perseverance and patience.

(9) Concentration of the attention.

§6. Suitable and Unsuitable Models

The objects which are most suitable as models for Clay-Modelling, and which will help most surely to develop these powers, are those which are simple in form, and yet have some element of grace or beauty in them, by reason of their variety of lines or graceful curves.

All objects given as models should be such that in reproducing them they must of necessity be moulded by the fingers. Those which can be turned out by a lathe, or a potter's wheel, or by any machine, better and more

accurately than by a skilful hand are, for that reason, not suitable. Geometrical forms should be avoided: they are uninteresting, and give only a mechanical training, besides lacking beauty and the element of art. The difficulty of making two sides of an object exactly alike is great, and does not occur in copying natural objects, of which the sides never quite match each other, however symmetrical they may appear. The exercise of balancing the masses rightly in copying the natural object is far more valuable. Geometrical forms possess no variety of lines to enforce observation, no beautiful curves to be enjoyed. They have only straight lines, sharp angles, or symmetrical curves, which can be turned out much better by machinery than by hand.

There still remains the choice between a course of Natural Objects and of Conventional Models, both being suitable for reproduction in clay. But here the tastes of the students themselves, especially of children, pronounce very strongly in favour of Natural Objects. Far more interest is aroused in a child by an object of which he already has some knowledge, and which has a connection with his everyday life, than by a comparative abstraction, which is strange to him. The child will try with greater zest to copy an object which he knows, than something which does not convey a clear idea to his mind. This interest will add much to the enjoyment of the work, and should be fostered by giving at first familiar objects as models, and then proceeding to the less known; although it will be found that there are few models in the following Course with which children are unacquainted.

To begin with conventionalised forms is to try and teach a child by means which are altogether beyond his ken—to use the abstract instead of the concrete; though it is only of the latter that he has any knowledge. The conventionalised form is merely an opinion, artistic or otherwise, about the natural form, which is a fact. Therefore, to properly understand the former we must first study the latter. A child is unable to comprehend why the one should differ from the other, and if he succeeds in recognising in the conventional form something which he knows, he will probably mistake that for the object as it is in Nature. That is, he mistakes an opinion, about which ideas may legitimately differ, for a fact. It is a matter of education to appreciate conventionalised form, and that education should begin by studying Nature herself. Later, of course, in an artistic training, the two must necessarily be studied together.

It has been urged in favour of conventional types that they can always be done 'in relief'—that is, projecting from a background—and that they are, therefore, better adapted for Clay-Modelling than objects which have to be modelled 'in the round,' because these latter are generally held in the hand while being worked, a method which, although it may seem to some easier for children, is against all the principles of the art. Objects modelled 'in the round,' unlike those modelled 'in relief,' are unattached to any background, and open on all sides except at the point which rests on the slab. The need, however, for holding the clay model in the hand is easily set aside by using the little armature described in §19, which, being buried in the model, supports it,

and makes it perfectly easy to work.

§7. *Choice of Methods in Working Models*

Although in this Manual accurate directions are given for the working of each model, it is not necessary that these should always be followed exactly, so long as the general principles of working laid down are adhered to. The end to be striven for is to obtain a lifelike representation of the object, not a copy that is merely slavishly accurate, with all the life smoothed and finished out of it. Finish itself is only of secondary importance compared with attaining the character of the model. We should be able to forget in looking at the copy that it is made of clay, so real should it appear.

A child who has any natural aptitude for Clay-Modelling may succeed better by doing the work in his own way, and not exactly according to the directions given. Originality of treatment, whether it follows the lines laid down in the directions or not, should be carefully encouraged and fostered, and by no means repressed.

§8. *Objects, and not Copies, to be Used as Models*

The objects themselves must be given as models, and not copies or imitations of them, however good these may be, because in working from a copy we are looking through other people's eyes, and therefore have not to use our own to the same extent. Thus a great part of the training is missed.

§9. Number of Models Required for a Class

A model should be provided for every student, or at least one to every two students, as otherwise accuracy of work is impossible. They should be able to examine the model closely; and it is of great assistance to pass the thumb over it, in order to feel the actual shape of the surface.

§10. Object-Lesson for Children

For Children, an object-lesson treating of the shape and general appearance of the object should be given before the modelling is attempted. This is specially necessary in the earlier lessons.

§11. Number of Pupils in a Class

Clay-Modelling cannot be properly taught to a class of more than twenty pupils. With a larger number it is not possible for a teacher to give the individual attention required.

For Children, the lesson may occupy about an hour, and the model should be finished in that time.

§12. Some Models to be Enlarged

The elder pupils should be taught to enlarge objects which are very small, such as a cockle-shell; while those which are large, like a loaf, may be decreased in size,

thus making a variation of exercise. This, however, should not be expected of very young children.

§13. Position of Model

The object should be placed in a natural position, and copied as it stands. If it is propped up by any means to keep it in place, and these means are not shown in the copy, the position is unnatural.

§14. Points to be Observed in Working

In modelling an object careful regard must be had, not only to its form and the shape of its various parts, but to the broad effect of light and shade, and of the individual shadows. It is one of the tests of good work that the shadows of the copy correspond with those of the model. To this end the object must always be in the same position as the copy. For instance, when turning the copy to work another side, the object must always be turned in the same way. The light, if possible, should only come from one side, so that the light and shade may be clearly defined; and the copy should not be brought up close to the eyes, but kept at a distance.

§15. Reasons for Using a Slab

All models, except those specified below, should be done on a slab of clay, which the pupil must first make, and which represents the table or board on which the object rests. We cannot properly consider an object

except in relation to its surroundings—it cannot hang in mid-air; and we must therefore show what these surroundings are.

Those models which do not require to be made with a slab are those only which might be actually used for the purpose for which they are obviously intended, such as a plant-pot, a pin tray, or a dish. Those which are merely representations of natural or other objects, such as an apple, or a boot, or a loaf, should always be worked on a slab. (See FIGURE F.)

It may be objected that to make a slab for every model occupies too much time. It is, however, a very simple operation, and as facility in work is gained it can be done very quickly, and should not occupy more than five minutes.

§16. Order of Models in Course

The order in which the models in this Course are arranged is not intended to be followed absolutely, but they are placed generally in order of difficulty, the easier ones at the beginning. Due variety of form should be observed in the order in which they are given as lessons, and not too many of the same shape taken in succession. Nor is it necessary that every model in the list should be worked. Some of them are only to be obtained at certain times of the year, and must, of course, be omitted when they are out of season. Others may have to be left out, as in some places they are difficult to procure.

§17. *Arrangement of Course for a Class of Children*

For a Class of Children a selection should be made of the most interesting models, and those which will prove most interesting to children are not necessarily the easiest. Three, or sometimes four, lessons may have to be given on each object, but care must be taken that the children do not become wearied by having the same model too often. It is best to interpose a new one, and then return later to the other. They may sometimes be asked to work from memory an object that they have already made, or be told to make some familiar thing which they have not as yet modelled.

§18. *Method of Working and Description of Tools*

In working the models the thumb and forefinger of either hand must be used as far as is possible—not the tip, but the ball of the finger or thumb; and the clay should be put on in such a way as to show the form of the surface it is desired to make. Thus, in doing a round surface we should give the thumb a circular motion; and for a flat surface it should have a straight motion. Where the thumb or forefinger cannot be used, wooden tools must be employed; and these should be curved, and not straight from end to end, as are many of the tools made. The fewer the tools and the less they are used, the better. Two useful shapes are illustrated (FIGURES A, B). The smaller one is suitable for young children, for whom the other may be too large. Tools must not be held like

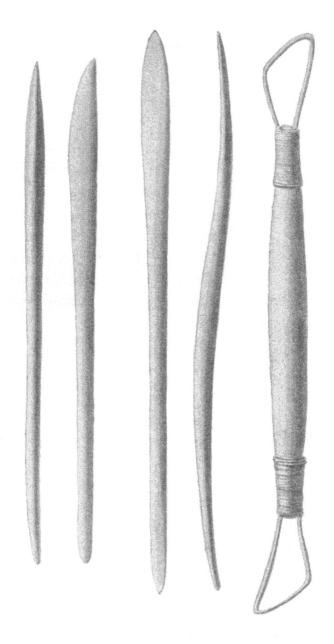

FIGURE A FIGURE B FIGURE C

a pencil, but grasped by all the fingers. A mirette, or rod with a wire loop (FIGURE C) at one or both ends, will be found very useful, especially for those models which require hollowing out, like the Sabot (MODEL 36). The fingers and tools must be constantly wiped on a damp sponge to keep them clean and free from clay, otherwise the dry clay off the fingers is worked into the model and the surface spoilt.

§19. Use of Armature

The clay model must not be held in the hand after the first general shape is obtained, but fixed on to an armature (FIGURE D), or iron upright, 1¾ inches high, screwed on to the modelling-board. It is against all the principles of the art for the student to hold the clay model in his hand while he is working on it. By doing so the work which has been already done is constantly being spoilt, and has to be commenced again, the model is pressed out of shape, the clay is dried by too much handling, and, moreover, the use of one hand is lost.

It is only in the case of the simpler rounded forms, like an orange, when the general shape can be rounded in the hands, that the model should be made at the commencement apart from the armature. In other cases it should be built up directly on the slab round the armature; but where the model does not need support, as in flat objects, like leaves, it should be simply worked on the slab without the armature.

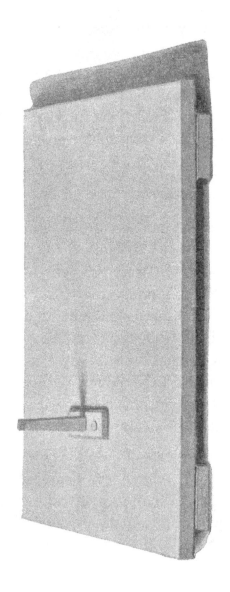

FIGURE D

§20. *Description of Modelling-board*

The modelling-board (FIGURE D) should be not less than 9 inches by 11 inches in area, and should either have two wooden bars screwed on to the bottom, across the grain of the wood, to prevent warping, or else have a piece of wood mortised on each end, like a drawing-board.

The armature must be fixed towards one end of the board (FIGURE D), to allow room for working those models which do not require it.

§21. *Kind of Clay to be Used*

Terra-cotta clay is the best material for the work. The red clay has the advantage of pleasant colour, and it is also, if properly prepared, smooth and free from grit.

§22. *Level Table to be Used*

When possible the pupils should work on a level table, not on a sloping desk. They may be allowed to stand if they like.

§23. *Order of Points to be Observed in Working Models*

The method to be followed in working the models is to proceed from the general to the particular, getting

first the general shape or mass of the object, noting its proportions, character, and light and shade. Until this is fairly correct it is of no use to go further. Then the details may be put in, the most noticeable first, and lastly the minor ones.

It is better to put in the details of the upper part of the model first, and then those of the lower part. If the latter are done first, the work may be lost and have to be done again, as the clay may be pressed down on to the slab in working the top.

§24. Definition of 'Mass'

The word 'mass' is here used in its technical sense, to denote the whole shape, or large divisions, of an object, considered without the details. It does not refer specially to size, and may be applied equally to a cockle-shell or a mountain. When an object is much cut up by the details, the masses may be more easily perceived with half-closed eyes.

§25. Models to be Built Up, not Cut Out

The mass should be built up of rather stiff clay, so that a solid foundation is made; but the modelling of the form must be done by putting on pieces of softer clay. For this reason the model at first should be made smaller rather than larger than the object, to allow for the increase of size caused by putting on more clay. The model must not be cut or carved out of a larger mass, as if one were working in wood or stone, in which

arts the principles of working are contrary to those of Modelling.

§26. Hollow Models

In the case of hollow models (Models 11, 12, 21, 29, 43, 48, 52, 58, 59) soft clay must be used, and the fingers kept moist with the sponge, or the clay will crack. These models should not be made less than ⅛ inch in thickness.

§27. Care of the Clay

The care of the clay is very important, as, unless it is in proper condition, good work cannot be done. It must not all be of the same consistency, but the softest should not adhere to the finger when it is touched, and the stiffer must not be so dry as to crack with a little handling. The best way to keep it is in a zinc-lined box with a lid; but, failing this, it may be kept in a pail covered with wet woollen cloths, with a piece of mackintosh over the top. After the lesson is finished the clay used should be broken up and sprinkled with water, more or less according to its dryness; but water should never be allowed to stand in the box.

If the clay is too soft, it must be kneaded in the hands until the right consistency is obtained; and if it is too hard the same method should be followed, using water until it is quite smooth and free from lumps.

A small wooden scoop (FIGURE E) will be found useful for getting the clay out of the box.

§28. Preservation of Work

When it is desired to preserve any piece of work, its slab should be detached from the board with a piece of thread or wire, and the model allowed to dry a little before it is lifted off the armature. After it is thoroughly dry it may be fired in a brick-kiln or baked in an ordinary oven, which should be cool when the models are put in. They will, however, last well when simply allowed to dry, if they are carefully treated.

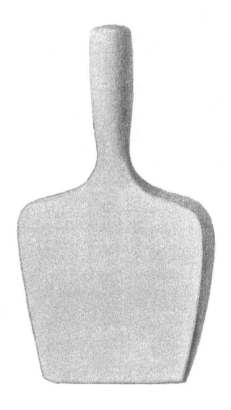

Figure E

§29. *Objections taken to Clay-Modelling*

It has been charged against Clay-Modelling that it is liable to spread infectious diseases in schools. No authentic case of such an occurrence has been found, and infection is far less likely to arise from clay than from books or from contact of clothes. It must be insisted on that the children come to the lesson with clean hands, and a child having anything the matter with its hands should not be allowed to touch the clay; or, if this is permitted, the clay thus used should not be mixed with the rest, but thrown away. If, however, stronger measures are desired, the clay may be sprinkled with Sanitas disinfectant instead of water, and then well kneaded up, so that the Sanitas is thoroughly incorporated with every part.

Clay has been known to develop a disagreeable odour, which has generally arisen from its having been put into a box which was not clean. No box which has contained any perishable material, such as butter, should ever be used. Clay is not an expensive material, and on its developing objectionable qualities should be at once thrown away; but if due care is taken this will not occur.

LIST OF MODELS

1. Orange
2. Apple
3. Plum
4. Pear
5. Piece of Broken Stone
6. Lemon
7. Pea Pod
8. Acorn
9. Laurel Leaf
10. Tomato
11. Saucer
12. Plant Pot
13. Onion
14. Potato
15. Broad Bean
16. Chestnut
17. Poplar Leaf
18. Carrot
19. Cockle Shell
20. Egg
21. Bon-bon Dish
22. Walnut
23. Pomegranate
24. Banana
25. Cockle Shell (concave)
26. Almond Nut
27. Ivy Leaf
28. Jerusalem Artichoke
29. Octagonal Cigar-ash Tray
30. Brazil Nut
31. Pair of Mussel Shells
32. Poppy Capsule
33. Windsor Bean
34. Pork Pie
35. Trinket Tray
36. Sabot or Clog
37. Mushroom
38. Mussel Shells (concave)
39. Oak Leaf
40. Tin Loaf
41. Tam-o'-Shanter
42. Child's Shoe
43. Pin Tray
44. Oyster Shell
45. Canoe
46. Sycamore Leaf
47. Cottage Loaf
48. Heart-shaped Dish
49. Cowrie Shell
50. Child's Boot
51. Poppy Head
52. Sugar Bowl
53. Plane Tree Leaf
54. Broad Bean (open)
55. Snail Shell
56. Boat
57. Pine Cone
58. Trefoil-shaped Saucer
59. Trefoil-shaped Cup
60. Whelk Shell

WORK FOR INFANTS

The Course set forth in this Manual is suitable for children of six or seven years of age and upwards, and in some cases for younger children. But for Infants of three or four years Clay-Modelling at first can only be play with a method in it. As far as possible, the same principles should be followed as with older pupils, and a model provided for each child, that opportunities for comparison may be afforded, even in the earliest lessons.

It is not advisable to trouble children of that age to make a slab. They will, therefore, unlike older pupils, have to be allowed to hold the clay model which they are making in their hands, as the use of an armature necessitates a slab. It is a great advantage to young children to learn to handle the clay, and to become accustomed to using it. They will be found greatly to enjoy its mere manipulation.

They may begin with the simplest objects, such as beads, round or flat, of different sizes; cherries with string or wicker stalks. The letters of the alphabet, or figures, may be made of strings of clay rolled out between the hand and board to ¼ inch thickness, or less. This is of service to the children in impressing the

shape of the letters on their minds. A sausage, or cigar; a small saucer, or a basket, made in the same way as Model 11; a bun, or an open pea-pod with loose peas in it made separately; a pat of butter, or a cottage loaf, are also suitable.

A bird's-nest is often considered an appropriate model for Infants, but is really far too difficult. Being composed of various materials, such as moss, hay, or feathers, its texture renders it unsuitable for reproduction in clay. It is impossible for a child to make it correctly and with truth. If he likes to make one on his own account, in the best way he is able, it is another matter.

ADVANCED WORK

For the work of advanced pupils, or for the higher classes in schools, more difficult subjects may be attempted. Those in the following list will be found suitable for studies:—

Sprays of the leaves of ivy, beech, oak, hazel (with or without nuts), hop, or rose.

Small branches of apple, pear, or plum, with the fruit attached.

A frond of hart's-tongue fern.

Sprays of the following flowers, with their leaves:— single dahlia, poppy, wild rose, convolvulus, clematis, iris, arum, tulip, nasturtium, daffodil.

A bow of ribbon, or a worn kid-glove, or a boy's cap.

All those above must be worked laid on a slab in relief, and should be copied from the object itself, as in the elementary course, and not from casts or other copies.

The following casts may also be used:—

Casts of parts of the human features, such as the nose, eye, mouth, or ear.

Casts of animals' heads, or the human profile; or masks of the human head taken from life or after death.

Casts of boldly designed ornament are very suitable, but difficult to procure, as most of those made are too full of detail or fine work to be adapted for modelling.

ADDITIONAL INSTRUCTIONS TO THE TEACHER

Each pupil (both Teachers and Children) must be provided with a board having an armature fixed upon it (FIGURE D), a sponge, a tool, sufficient clay, and a model.

For a Class of Children, the Teacher himself will also require all these materials, and he may work the model in front of the Class, the pupils following his directions. He should also make drawings on the blackboard to explain any points which will elucidate the lesson.

Neatness in working should be enforced, and the pupils must not be allowed to scatter little pieces of clay about the modelling-board and desk. The clay which forms the supply for use should all be kept in one lump, and thus untidiness avoided. Strips of American cloth or newspaper may be spread on the desks to prevent their being soiled. The children should be encouraged to bring aprons or pinafores with them for the modelling-lesson. The training thus given in cleanliness and neatness in work is valuable.

Before beginning the model a square or oblong slab of clay must be made on the modelling-board. It will

surround the armature, or not, according to the model (**§19**). Its shape and size depend on the model, which it must be large enough to hold with a margin all round. Small objects which have to be made on the armature, like a chestnut, require a thick slab, so that the armature does not show through the top of the model, which must never happen. The slab must always be placed so that its edges are parallel with those of the board.

Children may be allowed to smooth the slab and cut it square with a steel knitting-needle, that they may do it more quickly.

DIRECTIONS FOR WORKING THE MODELS

A Slab of Clay

(FIGURE F)

METHOD 1

1. Press pieces of stiff clay together on the board round the armature with the thumb, making the shape desired for the model. Be careful to give the slab the appearance of having right-angled corners from the first.

2. Make the slab about ¾ inch thick all over, or more if necessary for the model.

3. Smooth the top with the thumb, first in one direction, and then in the other.

4. Scrape off the uneven parts with the tool, and fill in any depressions with more clay.

5. Cut the sides straight with the tool, making them parallel with the edges of the board.

6. Smooth with the wet forefinger.

FIGURE F

METHOD 2 (*for children*)

1. Press pieces of stiff clay together on the board with the thumb so as to form the outline of a square or oblong, with the armature in the middle.

2. Fill in the outline with similar pieces of clay, making a thickness of about ¾ inch all over.

3. Smooth the top with the thumb, first in one direction, and then in the other.

4. Take one end of the knitting-needle in each hand, place it across the slab close to the armature, and draw it towards you, so as to cut the top perfectly smooth and even.

5. Do this in all four directions, turning the board round.

6. Wipe the knitting-needle on the sponge each time after using it.

7. Cut the edges of the slab straight by laying the knitting-needle on it parallel with the edge of the board, and press each end down on to the board.

8. Remove any pieces that are left behind.

9. Smooth the surface with the wet forefinger.

GENERAL DIRECTIONS
APPLYING TO ALL MODELS

1. Build up the mass of the object, making it smaller rather than larger than the object, unless it is desired to enlarge it.

2. Consider the proportions, the character, the general effect of light and shade.

3. From time to time hold up the modelling-board on a level with the eye, with the object and the model on it side by side in the same position, and compare them from all sides.

4. Observe the outlines as seen from all points, and the shape of the shadow cast by the model on the board. Also the shapes of the individual shadows on the model.

5. When the whole effect is fairly correct, put in the most noticeable details.

6. Then the minor details.

7. Give the texture of the surface, rough or smooth, etc.

DETAILED DIRECTIONS FOR WORKING THE MODELS

MODEL 1—AN ORANGE

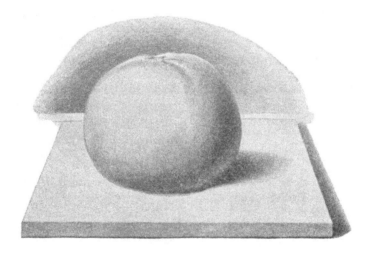

Directions

1. Make a square slab round the armature.

2. Take small pieces of stiff clay (see *§25*), and press them together on the board until a lump about the size of the Orange is made.

NOTE—This insures the lump being solid throughout, with no holes left in the clay.

3. Take the lump in the palm of the left hand, and roll it into a ball with the palm of the right hand, with a circular motion.

4. Smooth out any marks on the surface with the thumb.

5. Hold up the ball between the thumb and finger to observe the outline, pressing it into shape where necessary with the thumb.

NOTE—It is not necessary to strive to obtain a perfect ball, as its shape has to be spoilt again directly to make it like the Orange. It is quite enough to make it fairly round.

6. Press the ball into the general shape of the Orange, and put it on to the armature so that it touches the slab.

7. Hold up the board on a level with the eye, with the Orange and the model on it side by side in the same position, and compare their shape, noting at the same time the general mass, the proportions, and the shapes of the shadows from all sides.

8. Copy the form in the model by putting on pieces of soft clay and smoothing away the edges with the thumb, or by pressure of the thumb where necessary.

9. Carefully notice any flat parts.

10. Make the dimple at the top with the forefinger.

11. Pass the thumb round the dimple of the Orange to feel for any depressions. Make these in the model with the side of the thumb.

12. For the calyx, roll up a tiny pill of clay between the thumb and forefinger, flatten it, and shape it with the tips of the thumb and forefinger.

13. Wet the under side on the sponge, and press it into the dimple.

14. Work it up with the tool.

15. To give the roughened appearance of the skin, roll a tiny bit of clay backwards and forwards between the thumb and forefinger to partly dry it; blunt the end, and prick the surface of the clay model lightly and closely all over with it.

16. Partly efface the pricks with the thumb, that they may not be more noticeable than in the Orange.

MODEL 2—AN APPLE

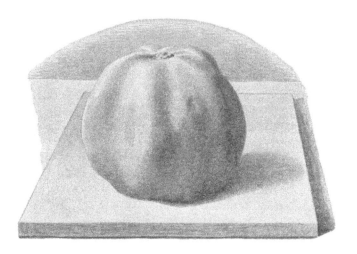

This object should be placed on its side, so that the dimples at each end can be seen, and not as in the illustration. It is best to use a piece of wicker or string for the stalk, as clay stalks break so easily.

Directions

1. Make a square slab round the armature.

2. Make a ball of clay about the same size as the Apple, (see MODEL 1, DIRECTIONS 2–8), press it into shape, and fix it on to the armature.

3. Observe the difference in circumference round the stalk end and round the calyx end, copying this in the model by putting on soft clay, or by pressure of the thumb.

4. Feel the dimple at the calyx end of the Apple with the thumb, to observe the depth and depressions around it. Make the dimple in the model with the forefinger slightly deeper, to allow for filling up with the calyx.

5. Mark the depressions with the side of the thumb, and model any little lumps by putting on soft clay.

6. Roll up a tiny pill of clay for the calyx between the thumb and forefinger, wet it on the sponge, and press it into the dimple.

7. Work it with the pointed end of the tool, carefully observing the form of the sepals in the Apple.

8. Make the dimple for the stalk with the forefinger.

9. Observe that in the Apple its sides are convex. Therefore fill it up to this shape with pieces of clay, smoothing with the tool.

10. Smooth the surface with the wet thumb.

11. Put in the stalk bending to one side.

Model 3—A Plum

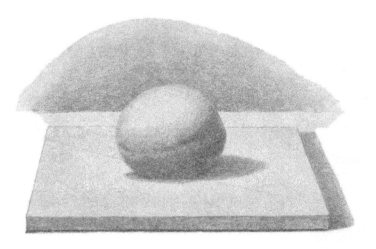

The Plum should be placed so that the groove on it can be seen. The stalk may be made of wicker or string.

Directions

1. Make an oblong slab round the armature.

2. Build up a lump of stiff clay (see **§25**) about the size and shape of the Plum.

3. Smooth out any marks on the surface with the thumb.

4. Put the lump on the armature.

5. Compare the object and the model, and correct the latter where necessary (see MODEL 1, DIRECTIONS 7, 8).

6. Make the dimple for the stalk with the forefinger, carefully modelling its form (see MODEL 2, DIRECTION 9), and feeling the form in the object with the thumb.

7. Make the groove by pressing the length of the tool into the clay model, and then smooth off the edges with the tool. Do not draw it on the clay with the point of the tool. Note that in the Plum it is not the same depth along its whole length.

8. Finish the groove by smoothing the wet thumb across it, and also smooth the whole surface.

9. Put in the stalk.

MODEL 4—A PEAR

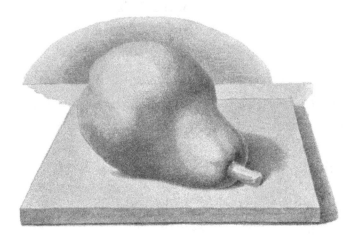

The Pear should be placed on its side, so that the modelling of the whole can be seen. Use a piece of wicker or string for the stalk.

Directions

1. Make a slab round the armature.

2. Build up the mass of the Pear (see MODEL 3, DIRECTIONS 2, 3), and put it on the armature.

3. Compare the mass of the object and the model, correcting the latter where necessary (see MODEL 1, DIRECTIONS 7–9).

4. Feel the dimple in the calyx end of the Pear, and make it in the model with the forefinger, finishing it with the tool.

5. Carefully model the stalk end, noting that the curves on one side are convex, but concave on the other, and that the stalk is probably on one side.

6. Smooth the surface with the wet thumb.

7. Put in the stalk.

MODEL 5—A PIECE OF BROKEN STONE

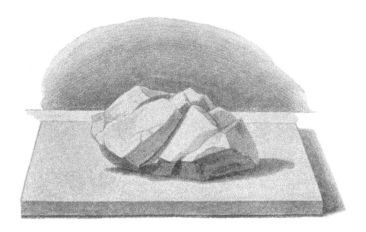

Directions

1. Make a slab round the armature.

2. Build up the general shape of the Stone on the slab round the armature.

3. Make the sharp edges by putting clay on in the direction of the edge, and smoothing the thumb, first along the plane on one side of it, and then along the plane on the other.

4. Compare the masses of the object and the model (see MODEL 1, DIRECTIONS 7–9), carefully noticing the angle of inclination of the different planes.

5. Smooth with the wet thumb if the surface of the Stone is smooth. Otherwise, roughen it by dabbing with a bit of rather soft clay, or with the finger.

MODEL 6—A LEMON

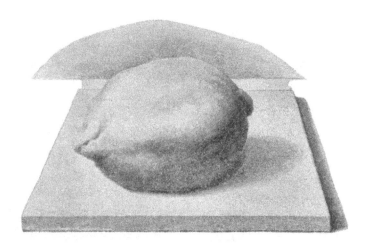

Directions

1. Make an oblong slab round the armature.

2. Build up the mass of the Lemon, and put it on the armature (see MODEL 3, DIRECTIONS 2–4).

3. Compare the mass of the object and the model by holding them up on a level with the eye (see MODEL 1, DIRECTIONS 7–9).

4. Work up the stalk end. Note any depressions, putting on the higher parts between these.

5. Finish the attachment of the stalk with the tool.

6. Give the texture of the surface by pricking it with a piece of clay (see MODEL 1, DIRECTIONS 15, 16). The point of the clay-pricker should be blunter than that used for the Orange.

MODEL 7—A PEA POD

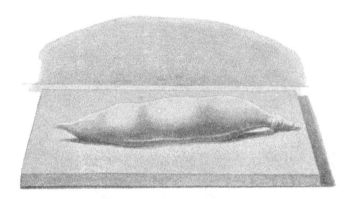

This object does not require the support of the armature (see *§19*).

Directions

1. Make an oblong slab away from the armature.

2. Build up the mass of the object of stiff clay (see *§25*), making it rather smaller than in the original, to allow for the modelling later. Roll it between the hands to smooth it, and put it on the slab.

3. Compare the masses of the object and the model (see MODEL 1, DIRECTIONS 7–9). Model the top first, and when that is finished do the part underneath.

4. Shape the ends with the forefinger and tool.

5. Mark the join of the two parts of the pod with the tool, smoothing away the edges made in the process.

6. Smooth the surface with the wet thumb.

MODEL 8—AN ACORN

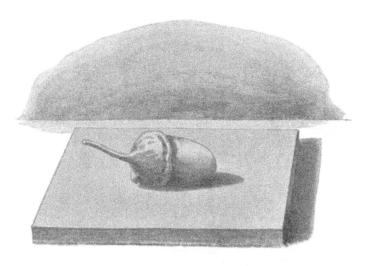

This model should be made twice its natural size.

Directions

1. Make a small oblong slab, 1½ inches thick, round the armature.

2. Make the Acorn first, and then put the cup round it.

3. Build up the mass of the Acorn (see MODEL 3, DIRECTIONS 2, 3).

4. Put it on the armature, noting the angle at which the Acorn is lying on the table.

5. Put on pieces of clay round the end for the cup, making it the right thickness and shape.

6. Finish the edge of the cup with the tool.

7. Imitate the roughness of the cup with the tool and finger.

8. Smooth the clay Acorn with the wet finger, making the point at the end.

9. Roll out a little piece of clay for the stalk, and put it in place, or use a bit of twig or string.

Model 9—A Laurel Leaf

The Leaf must be copied in the position in which it lies on the table. It does not need the support of the armature (see *§19*).

Directions

1. Make a slab which will hold the Leaf, allowing a margin of ½ inch all round.

2. Sketch the outline of the Leaf on the slab with the tool. Do not lay the Leaf on the slab and trace round it.

3. Build up the model inside the outline quite solid, beginning at the highest point, and make this stand up above the slab as much as the same part of the Leaf does above the table. Work from the highest to the lowest parts.

4. Carefully note all irregularities of surface and edge, copying these in the clay model.

5. Make the stalk solid underneath, observing its curve downwards.

6. Smooth the surface with the wet thumb.

7. The midrib looks lighter than the Leaf itself. To produce this effect it must be raised. Therefore depress the clay slightly along each side of the rib with the tool, thus leaving a narrow ridge.

8. Lightly mark the lateral ribs, if they are noticeable enough in the Leaf, by a single instead of a double depression.

9. Slightly cut out the clay underneath the model, to give it the appearance of being thin at the edge, being careful in so doing not to spoil the shape.

NOTE—It is, of course, impossible and unnecessary to make the model as thin as the Leaf. The clay underneath should therefore only be cut out just at the edge, and the rest left solid.

MODEL 10—A TOMATO

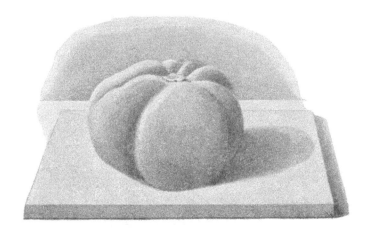

Directions

1. Make a slab round the armature.

2. Build up the mass of the object (see MODEL 3, DIRECTIONS 2, 3), and put it on the armature.

3. Make the dimple which holds the calyx, with the forefinger, a little deeper than in the object, to allow for filling up with the calyx. Smooth away any edges with the forefinger.

4. If the divisions of the lobes are only slightly marked, put them in by pressure with the tool, noticing that they are deepest near the calyx, and soften them by passing the forefinger across them.

5. If the divisions are deeply marked the mass must be made somewhat smaller than the Tomato at first.

6. Then lightly draw the divisions, to show where they come, and make each lobe by putting on a piece of clay down the middle of each division, between the lines, smoothing it away on each side, so that the middle of the lobe is higher than the edges.

7. Smooth the surface with the wet thumb.

8. Count the sepals in the calyx, and make the same number of tiny rolls of clay, flattening them on the board, and making them pointed at one end, as in the original.

9. Press the other ends together, observing the angles between the sepals; wet the under side, and press it into the dimple.

10. Roll up a tiny clay stalk the same size as in the object, wet one end on the sponge, make a little hole in the calyx with the tool, and put it in.

11. Curl up the sepals, if necessary.

MODEL 11—A SAUCER

This model and the next—the Plant Pot—should be made in the same lesson, that they may match in size, as the Plant Pot is intended to stand in the Saucer. They should not be less than ⅛ inch thick all over.

Directions

1. Make two balls of clay (see *§15* and *§26*), each 2 inches in diameter. They should be made as round as possible.

2. For the Saucer, flatten one ball on the board, with the ball of the thumb, to the thickness of about ¾ inch.

3. Loosen this disc from the board, and, putting the tips of the thumbs together in the centre, take hold of the edge with the forefingers and draw the thumbs towards them, so as to hollow out the middle.

4. Do this all round the disc, turning it round and round, but keeping it on the board, and always working at the side opposite to you.

5. Be careful not to press downwards too much with the thumbs, or a hole will be made in the bottom of the saucer.

6. Take hold of the rim between the thumbs and forefingers, and pinch it to an even thickness and height all round, giving it a graceful upward curve.

7. Smooth the rim, inside and outside, in a circular direction, with the wet thumb, being careful to have the same curve upward all round.

8. Make five or six marks at equal distances on the edge, and bend it outwards at each mark between the thumb and fingers, or otherwise ornament it, making the ornamentation an essential part of the form of the Saucer.

MODEL 12—A PLANT POT

Directions

1. Take the second ball made for the last model, and, placing the thumbs back to back, push them into the middle, drawing the outside upwards with the forefingers.

2. Do this all round, turning the model round, but keeping it on the board, and always working at the side opposite to you.

3. Be very careful not to make the Pot too wide at the top, though the top must be larger in diameter than the bottom.

4. Pinch the sides to the same thickness and height all round, keeping the thumbs inside all the while.

5. Flatten the bottom, inside, with the finger.

6. Make the hole in the bottom with the forefinger, pushing it through first from the inside, and then from the outside.

7. Finish with the wet thumb and finger, and crinkle the edge of the Pot to match the Saucer.

MODEL 13—AN ONION

Directions

1. Make a square slab round the armature.

2. Roll up a ball of clay (see MODEL 1, DIRECTIONS 2–5).

3. Slightly flatten it on two diametrically opposite sides, and put it on the armature, being careful to give the planes the same inclination as in the object.

4. Compare the masses of the object and the model (see MODEL 1, DIRECTIONS 7, 8), building up the top—which becomes thin and papery at the end—and also the rootlets.

5. Give the appearance of the rootlets by making a number of little sharp cuts with the tool, carefully

observing in the object the direction these should take.

6. Finish the top end by giving any sharp twists or turns which may occur in the original.

7. Smooth the surface with the wet thumb.

MODEL 14—A POTATO

Directions

1. Make an oblong slab round the armature.

2. Proceed as for MODEL 3 (DIRECTIONS 2–5).

3. Carefully observe the shape and position of the eyes in the Potato, marking these in the clay model and softening the edges.

4. Work up the dot in the eye with the pointed end of the tool.

Model 15—A Broad Bean

Directions

Proceed as for the Pea Pod (Model 7).

Model 16—A Chestnut

This model should be enlarged to twice its natural size.

Directions

1. Make a thick slab round the armature.

2. Build up the mass of the object on the slab round the armature.

3. Smooth away all marks in the clay with the thumb, and correct the shape by comparison with the object (see MODEL 1, DIRECTIONS 7, 8).

4. Work up the point, and smooth the surface with the wet thumb.

5. Draw the outline of the scar with the tool.

MODEL 17—A POPLAR LEAF

Directions

Proceed as for the Laurel Leaf (MODEL 9).

MODEL 18—A CARROT

The armature should be buried in the thick end of the model, and must, therefore, not be in the middle of the slab, but towards one end. Cut off the leaves to within about ½ inch of the Carrot.

Directions

1. Make an oblong slab with the armature near one end.

2. Proceed as for MODEL 7 (DIRECTIONS 2, 3).

3. Observe the different planes on the Carrot, and copy these, carefully modelling them with the thumb.

4. Do the top first, and then the part underneath.

5. Round the thick end with the thumb, and make a depression in the middle of it with the forefinger.

6. Put some clay in this depression for the stalks, and cut it with the sharp end of the tool, first observing the stalks in the Carrot.

7. Copy the marks on the Carrot, carefully noting that some are deeper than others, and that their distance from each other and their length vary.

MODEL 19—A COCKLE SHELL

This model should be enlarged to twice its size.

It does not need the support of the armature (see *§19*).

Directions

1. Make a slab away from the armature large enough to allow a margin of ½ inch all round the model.

2. Sketch the outline of the Shell on the slab with the tool. Do not lay the Shell on the slab and trace round it.

3. Build up the shape of the Shell inside the outline, making it solid, and beginning at the highest part.

4. Compare the proportions, masses, shadows, and outlines of the object and the model (see MODEL 1, DIRECTIONS 7, 8), altering the latter where necessary.

5. Smooth the surface with the wet thumb or finger.

6. Put in the grooves with the tool, observing that they all meet in one point, and smooth away any sharp edges that are made in drawing them.

MODEL 20—AN EGG

Directions

Proceed as for MODEL 3.

MODEL 21—A BON-BON DISH

Directions

1. Make a ball of clay (see *§15* and *§26*) 1½ inches in diameter.

2. Flatten this to the thickness of ¾ inch.

3. Loosen the disc from the board, and hollow it out with the tips of the thumbs (see Model 11, DIRECTIONS 3–6) till the sides are ⅛ inch in thickness all over.

4. Make the sides about 1 inch in height, and let them slope outwards, the circumference at the top being wider than that at the bottom.

5. Smooth all over with the wet finger.

6. Divide the circumference into six equal parts, and at each division bend the edge inwards, being careful to make all the curves alike.

MODEL 22—A WALNUT

This model should be enlarged to twice its size.

Directions

1. Proceed as for MODEL 3 (DIRECTIONS 1–5).

2. Roll out a small string of clay between the finger and the board, flatten it, wet one side on the sponge, and press it round the middle of the model for the rim.

3. Work it up with the tool so that the join cannot be seen.

4. Notice that the rim is wider round one end of the Walnut than round the other, and copy this in the model.

5. Work up the point at the end with the tool, and draw the mark on the rim showing where the two halves of the shell join.

6. Smooth the surface, and carefully draw the principal markings on the shell, partly effacing them afterwards with the finger.

MODEL 23—A POMEGRANATE

Directions

1. Proceed as for MODEL 1 (DIRECTIONS 1–9).

2. Build up the calyx at the top, working it to the right shape with the finger and tool.

3. Show the divisions of the sepals by cuts in the clay.

4. Smooth the surface with the wet thumb.

MODEL 24—A BANANA

Directions

1. Make an oblong slab round the armature.

2. Proceed as for MODEL 3 (DIRECTIONS 2–5), giving the model the proper curve when it is put on to the armature.

3. Observe that the long planes of the Banana are flat or convex—rarely concave. Make these by smoothing the thumb along the clay model, and by putting on clay to form the edge of the plane (see MODEL 5, DIRECTION 3).

4. Work up the ends to the right shape.

5. Smooth the surface with the wet thumb.

Model 25—A Cockle Shell (concave)

The Shell must be placed on the table with the hollow side upwards. The model must be made twice the size of the Shell, and only the inside can be modelled.

Directions

1. Make a slab, away from the armature, which will allow a margin of ½ inch all round the model.

2. Sketch the outline of the Shell on the slab.

3. Observe the height of the highest point of the Shell, and the angle at which it lies on the table.

4. Build up the form of the Shell, leaving the hollow in the middle, and making it solid underneath up to the edge.

5. Model the inside carefully, putting in the grooves with the tool.

6. Work up the edge, cutting it out a little underneath to show the thickness just at the edge.

7. Model the curl of the Shell, and slightly indicate the markings with the tool.

MODEL 26—AN ALMOND NUT

This model must be made twice the size of the object.

Directions

1. Proceed as for MODEL 3 (DIRECTIONS 1–5).

2. Make a tiny string of clay for the rim round the Nut, flatten it, and work it on with the tool.

3. Smooth the surface with the wet thumb, and put in the dots with the sharp end of the tool, first noticing their position on the Nut.

MODEL 27—AN IVY LEAF

Directions

Proceed as for the Laurel Leaf (MODEL 9). In sketching the Leaf on the slab, put in first the five chief ribs, noticing the angles between them. Then draw the outline around the ribs.

MODEL 28—A JERUSALEM ARTICHOKE

Directions

1. Proceed as for MODEL 3 (DIRECTIONS 1–4).

2. Make the mass in the first instance smaller than the Artichoke, to allow for putting on the knobs later.

3. After getting the proportions correct, put on the knobs, modelling each to its particular shape.

4. Smooth the surface with the wet finger, and roughen the ends of the knobs with the tool.

MODEL 29—AN OCTAGONAL CIGAR-ASH TRAY

Directions

1. Build up an oval shape of clay (see *§15* and *§26*) about 3 inches by 1½ inches in size.

2. Flatten this on the board to the thickness of about an inch.

3. Hollow it out with the tips of the thumbs, keeping the oval shape (see MODEL 11, DIRECTIONS 3–5). It should be made about ⅛ inch thick all over.

4. Make the edge perpendicular, and the same thickness and height all round.

5. Smooth the surface, inside and out, with the wet thumb.

6. At the opposite ends of the longest and shortest diameters form the angles of the sides by pressure with the thumb and fingers.

MODEL 30—A BRAZIL NUT

This model should be enlarged by one-half of its size.

Directions

1. Proceed as for MODEL 5 (DIRECTIONS 1–4).

2. Make the marks on the surface with the pointed end of the tool, noticing that near the edges they are lines, more or less wavy, while in the middle they are dots.

3. Slightly efface the markings in places, so that they may not be too noticeable.

Model 31—A Pair of Mussel Shells (convex)

The Shells should not be separated, but pressed flat on to the table, hollow side downwards, and copied in that position. The model should be made half as large again as the Shells.

Directions

Proceed as for the Cockle Shell (Model 19). Be careful to make the angle the two Shells form with each other correct in sketching the outline on the slab.

MODEL 32—A POPPY CAPSULE

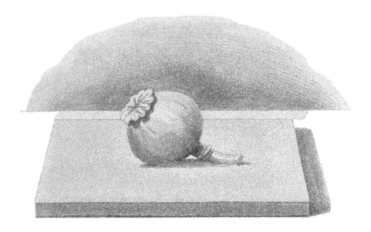

This model may be enlarged to twice its size. Leave the stalk about 1 inch long.

Directions

1. Proceed as for MODEL 1 (DIRECTIONS 1–9).

2. Put on a piece of clay for the disc of the Capsule, and work it to the right shape with the tool.

3. Roll up a tiny piece of clay for the stalk, wet one end, and press it on to the model.

4. Put a little piece of clay round the join, and smooth it on with the tool.

MODEL 33—A WINDSOR BEAN

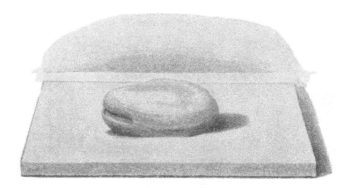

The Beans should be soaked in water for a day or more before they are used, so that they may not be wrinkled. The model should be made twice the size of the Bean. It does not need the support of the armature.

Directions

Proceed as for MODEL 7.

Model 34—A Pork Pie

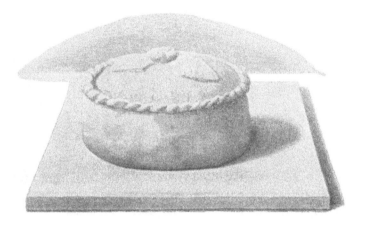

Directions

1. Make a square slab round the armature.

2. Build up the shape of the Pie on it, making it solid.

3. Model the top and the rim, copying all the irregularities in the original.

4. Smooth the sides, putting in any bulges or indentations that occur in the Pie.

Model 35—A Trinket Tray

The shape of this Tray is based on the form of an elongated cockle-shell.

Directions

1. Make an oval shape of clay (see *§15* and *§26*) 2 inches by 1 inch in size.

2. Make one end of it narrower than the other, and flatten to ¾ inch thickness.

3. Hollow it out with the tips of the thumbs, making it ⅛ inch thick all over (see Model 11, Directions 3–6), keeping the same shape all the time.

4. Make the sides slope up gradually with a graceful curve.

5. Smooth with the wet thumb.

6. Mark off even distances on each side of the centre of the wider end of the Tray, and crinkle the edge evenly on each side (see Model 11, Direction 8), so that the corresponding curves match each other.

MODEL 36—A SABOT

The armature should be buried in the tread of the Sabot, and must, therefore, be nearer one end of the slab than the other. A Clog may be used for the model instead of the Sabot, if the latter is not obtainable.

Directions

1. Make an oblong slab with the armature towards one end.

2. Build up the mass of the object on it, turning the Sabot and the clay model about, so as to see first the width, and then the length and height.

3. Make the clay model solid throughout, and when the modelling of the outside is finished, cut out the instep, and then the inside, with the mirette, leaving the sides about ⅛ inch thick.

4. Smooth with the wet thumb.

Model 37—A Mushroom

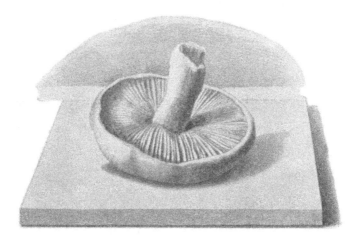

The Mushroom should be copied as it lies on the table with the stalk upwards. It does not require the support of the armature.

Directions

1. Make a square slab.

2. Sketch the outline of the top of the Mushroom on it.

3. Build up the shape of the top inside the outline, beginning in the middle, and leaving a slight depression for the stalk.

4. Make it solid underneath, except just round the edge.

5. Model the upper surface carefully, observing the undulations in the Mushroom.

6. Work up the edge with the finger and tool.

7. Mark the gills with the pointed end of the tool, noting the special direction the lines should take. Put in a few on one side, then a few on another, and then fill up the spaces between.

8. Make some of the marks deeper than others, as in the Mushroom. Also, break them up in places, if necessary.

9. Roll up a small piece of clay for the stalk, shape it properly, wet the end on the sponge, and put it in its place.

10. Cut out the clay underneath the model a little more with the tool, being careful not to spoil the shape in so doing.

MODEL 38—A PAIR OF MUSSEL SHELLS (concave)

The Shells must be placed with the hollow side upwards, and the clay model made half as large again as the Shells. Only the inside can be modelled.

Directions

Proceed as for the Concave Cockle Shell (MODEL 25).

MODEL 39—AN OAK LEAF

Directions

Proceed as for the Laurel Leaf (Model 9).

MODEL 40—A TIN LOAF

This model must be decreased in size.

Directions

1. Make an oblong slab round the armature.

2. Build up the mass of the Loaf on the slab, being careful to make it look oblong from the beginning.

3. Compare the object and the model for the proportions and general character, noticing the curves of the top and the way it is joined to the sides (see MODEL 1, DIRECTIONS 7, 8).

4. Smooth the rounded top, and work up the division between the top and sides, giving the broken appearance with the tool.

5. Copy any indentations there may be in the sides.

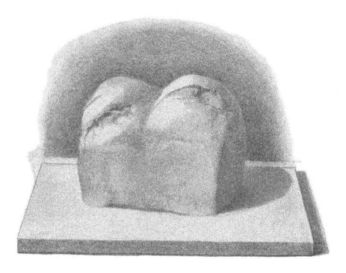

MODEL 41—A TAM-O'-SHANTER

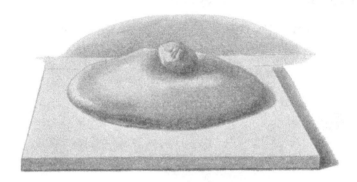

This model must be decreased in size. It should be made about 4½ inches in diameter.

Directions

1. Make a square slab away from the armature.

2. Build up the shape of the object, making it solid, and noticing the angle which the top forms with the table.

3. Build up the mass of the tassel on the top.

4. Carefully model the top, making the edge look soft and rounded.

5. Cut out the part underneath the crown with the tool, and model it to the right shape.

6. Make deep cuts in the tassel to give the texture.

MODEL 42—A CHILD'S SHOE

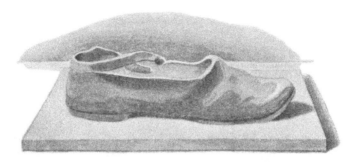

This model does not require the support of the armature.

Directions

1. Make a slab, and build up the mass of the toe of the Shoe on it, making it solid.

2. Roll a piece of clay between the hands, flatten it to the thickness of ⅛ inch, and cut out a strip of the right length and width for the part round the heel.

3. Join this on neatly, having first built up the sole and heel of the Shoe.

4. Carefully model the toe, putting in all the creases or other marks, and cut it out underneath the sole at the toe.

5. Hollow out the toe a little, leaving the top ⅛ inch thick.

6. Roll out a string of clay for the strap, flatten it, cut the edges straight, and join it on round the heel.

7. Mark the button-hole, and put on a piece of clay for the button.

Model 43—A Pin Tray

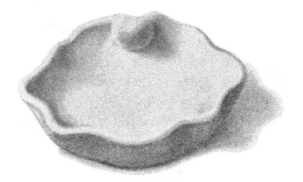

The shape of this Tray is based on the form of a Cockle Shell.

Directions

1. Make a ball of clay (see *§15* and *§26*) 1½ inches in diameter.

2. Flatten it to the thickness of 1 inch.

3. Divide the circumference into four equal parts, and hollow out three of these with the thumbs (see Model 11, Directions 3–7), leaving the fourth part for the curl of the shell. The sides should be nearly 1 inch in height, and should curve upwards gradually.

4. Place the thumbs on the outside of the fourth part, and make it curl upwards and inwards from each side, the two curves meeting in an angle in the middle of it.

5. The curl should stand up higher than the rest of the rim.

6. Smooth with the wet thumb.

7. Divide the rim of the Tray into two equal parts, and crinkle it evenly on each side of the division, so that the corresponding curves match each other.

Model 44—An Oyster Shell

The Shell should be placed with the inside upwards. It does not need the support of the armature.

Directions

1. Make a slab of clay large enough to hold the model, with a margin of ½ inch all round.

2. Sketch—not trace—the outline of the Shell on the slab.

3. Build up the mass of the Shell inside the outline, making it solid underneath, and beginning at the highest part.

4. Draw the outline of the black mark, and feel the surface of the Shell with the thumb to observe the modelling. Copy this carefully.

5. Work up the edge with the tool.

6. Cut out underneath the edge a little, to show the thickness of the Shell.

7. Smooth with the wet finger.

MODEL 45—A CANOE

This model should be made about 6 inches long.

Directions

1. Make an oblong slab.

2. Build up the mass of the Canoe, making it solid inside.

3. Model it to the right shape, and when the outside is finished, hollow out the inside with the mirette.

Model 46—A Sycamore Leaf

Directions

Proceed as for the Laurel Leaf (Model 9).

In drawing the Leaf on the slab, put in the ribs first, and then the outline round them.

Model 47—A Cottage Loaf

This model must be decreased in size.

Directions

1. Make a square slab round the armature.

2. Build up the mass of the Loaf round the armature, noticing the angle of inclination of the top of the Loaf.

3. Model it with soft clay to the exact shape of the object (see Model 1, Directions 7, 8), carefully noticing all irregularities of surface.

4. Work up the indentation between the top and bottom parts.

5. Make the depression in the top, and model it to the right shape (see Model 2, Direction 11).

MODEL 48—A HEART-SHAPED DISH

This model is shaped like a heart, but the rounded end is higher than the pointed one.

Directions

1. Make an oval lump of clay (see *§15* and *§26*) 1½ inches long, one end of which comes almost to a point, the other being 1¼ inch across.

2. Flatten this to 1 inch in thickness.

3. Hollow it out with the thumbs, keeping the oval shape (see MODEL 11, DIRECTIONS 3–7). The sides should be nearly 1 inch in height, and ⅛ inch in thickness, and have a rather sharp upward curve. They should be the same height all round.

4. Smooth all over with the wet finger.

5. Make the pointed end by pressing the sides together between the thumb and forefinger.

6. Divide the other end into two equal parts, and at the point of division press the edge inwards, making the two lobes of the heart, thus making this end higher than the other.

MODEL 49—A COWRIE SHELL

Unless a Shell at least 2 inches across is used as a model it should be enlarged in size.

Directions

Proceed as for the Cockle Shell (MODEL 19), but using the armature.

MODEL 50—A CHILD'S BOOT

Directions

1. Proceed as for the Sabot (MODEL 36, DIRECTIONS 1, 2).

2. Make the clay model solid up to the ankle, and about ⅛ inch thick above, except just at the edge.

3. Roll out a piece of clay for the upper part above the ankle, flatten it, cut it to the right length and width, and join it on neatly.

4. Model the toe carefully, marking the divisions of the sole and golosh, the toe-cap, and the uppers.

5. Cut out underneath the instep and sole, and make the bottom of the heel smaller than the top.

6. Model the part round the heel and ankle, keeping the finger of the left hand inside, to prevent the clay being pressed inwards.

7. Roll up tiny pieces of clay for the lace, and put them in place, working a little hole round each end with the tool. Pierce the rest of the holes.

8. Flatten a piece of clay for the tag, cut it to the right shape, wet it, and press it on inside, giving it the same position as the one in the object.

Model 51—A Poppy Head

Directions

1. Proceed as for Model 1 (Directions 1–8).

2. Put on clay for the disc on the top, and cut it deeply with the tool, to mark the divisions.

3. Roll up a piece of clay for the stalk, wet one end, and fasten it on, putting more clay round the join with the tool.

MODEL 52—A SUGAR BOWL

Directions

1. Make a ball (see *§15* and *§26*) 2 inches in diameter, and flatten it to a disc about 1 inch thick.

2. Hollow it out with the thumbs, and when a hole 1½ inches in diameter is made, work them underneath the edge so as to form a bulb-shaped hollow, narrow at the top.

3. Hollow the bulb out till the sides are ⅛ inch thick, and make the bottom of the Bowl thinner at the edge than in the middle by smoothing it only round the sides, leaving the middle untouched.

4. Work out the thick edge horizontally above the narrow top of the bulb, between the thumb and fingers,

to ⅛ inch in thickness and about 1 inch in width, being careful to make it the same width all round.

5. Smooth with the wet finger all over.

6. Bend up the edge irregularly in any way fancied.

MODEL 53—A PLANE-TREE LEAF

Directions

Proceed as for the Laurel Leaf (MODEL 9).

MODEL 54—AN OPEN BEAN POD

Directions

Proceed as for the Pea Pod (MODEL 7).

Model 55—A Snail Shell

This model should be enlarged to twice its size. It should be done round the armature.

Directions

1. Make a square slab round the armature.

2. Build up the mass of the Shell, making it solid.

3. Carefully draw and model the spiral with the tool.

4. Cut out underneath the edge of the Shell.

5. Hollow out the orifice a little, showing the thickness of the Shell only at the edge.

Model 56—A Boat

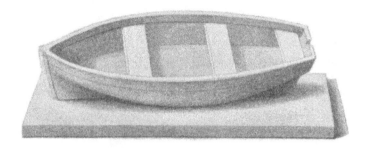

The Boat should be copied as it lies on its side on the table. The model should be made about 6 inches long. It does not need the support of the armature.

Directions

1. Make an oblong slab.

2. Build up the mass of the Boat on the slab, making it solid inside. Observe the angle which the keel makes with the table.

3. Carefully model the side which is uppermost, feeling the object with the thumb, and work only as far underneath as can be seen.

4. Scoop out the inside with the mirette, making it shallower than in the object, and the sides thicker, except at the edge.

5. Smooth the surface with the wet thumb.

6. Make the groove round the edge where the seats fit.

7. Roll up small pieces of clay for the seats, flatten them, cut the edges straight, and make them the right length.

8. Wet the ends on the sponge, and put them in place.

MODEL 57—A PINE CONE

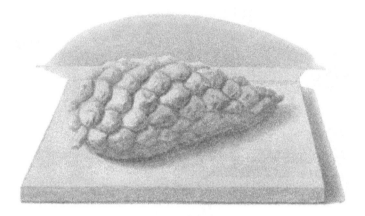

Only unripe Cones should be used as models, and they should be enlarged to 3 or 4 inches in size.

Directions

1. Proceed as for MODEL 3 (DIRECTIONS 1–5).

2. Lightly draw lines across the model at the same angle as the scales on the Cone, to indicate their divisions. Observe that they are curved, not straight.

3. Model the scales to the right shape by putting on clay.

4. Make the stalk, and put it in place.

MODEL 58—A TREFOIL-SHAPED SAUCER

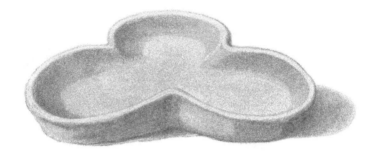

Directions

1. Make a ball (see *§15* and *§26*) 1½ inches in diameter, and flatten it to ½ inch in thickness.

2. Divide the circumference into three equal parts, and hollow out each part with the thumb (see MODEL 11, DIRECTIONS 3–7), so as to have three separate lobes.

3. Be careful to make all the lobes alike in shape, thickness, and height, and give the sides a graceful curve upwards. They should be ⅛ inch in thickness.

4. Smooth the surface with the wet thumb, inside and out.

Model 59—A Trefoil-shaped Cup

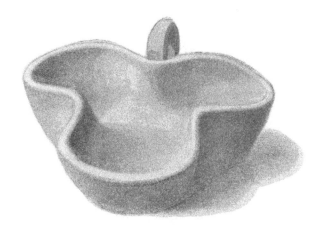

Directions

1. Make a ball (see *§15* and *§26*) 1 inch in diameter.

2. Proceed as for the Trefoil-shaped Saucer (Directions 2, 3), without first flattening the ball.

3. Make the sides slope outwards towards the top.

4. For the handle, roll a string of clay 2 inches long.

5. Flatten this slightly along its whole length, and flatten both ends till they are quite thin; wet them, and press them on to the cup in one of the divisions of the lobes, working them on with the tool.

Model 60—A Whelk Shell

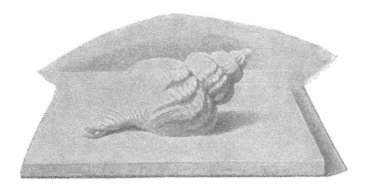

Unless Shells 2½ inches in length are used the model should be enlarged.

Directions

Proceed as for the Cockle Shell (Model 19), using the armature.

GENERAL DIRECTIONS FOR ADVANCED WORK

For Advanced Work the student will need a larger modelling-board (the size of which depends on the models to be worked), without an armature attached, and a few more tools of different shapes. It is best that he should choose these as he feels the special need of them. The modelling-board should be made of unplaned wood, to give the clay a firmer hold.

For working most of the subjects mentioned the board should be placed on an easel, or otherwise kept in an upright position, with the light falling from one side; and the easel should be turned about from time to time, so that the light may not always fall in the same direction. When not in use the board should be laid flat, and damp cloths spread over the work to keep the clay soft.

When the subject is a study of a spray of leaves or flowers, these should be pinned or fastened on to the board by the side of the work. Casts should also be hung on a level with the copy.

The Glove and the Boy's Cap may be worked with the board flat on the table.

Reliefs—Wet the modelling-board with the sponge, and build up a slab of clay of the required size and thickness. A long straight-edged piece of wood may be used to scrape the top perfectly smooth. Sketch the outline of the design or subject to be copied on the slab with a tool, and broadly block-in the whole, building it up to the required height. If it is to be done in lower relief than the original, the height of the highest point must be decided on, and this part put in first, all the rest being kept relative to it. It is the general effect of light and shade that the student must attempt to give, and he may render this by any means he likes.

When the whole has been blocked-in, it may be gradually worked up, and details put in; but it should, as far as possible, be kept in the same state all over, and the student must not try to finish one part when others are but just begun.

Casts of Ornament—These are worked in the same way as reliefs.

Casts of Animals' Heads or of the Features, or Masks of the Human Head—These need not be worked on a slab, but can be built up directly on the modelling-board, which has first been wetted.

If it is desired to keep any of these models when finished, they should be hollowed out behind when the clay is dry enough to allow of this being done without spoiling the work, and holes bored for a string or wire,

by which to hang them up. When they are perfectly dry they may be fired in a kiln, though the risk of breakage or cracking is considerable. Or they may be cast in plaster while still soft.

CPSIA information can be obtained
at www.ICGtesting.com
Printed in the USA
BVHW052219151022
649558BV00004B/155